architect

W9-DDE-344

National
Gallery

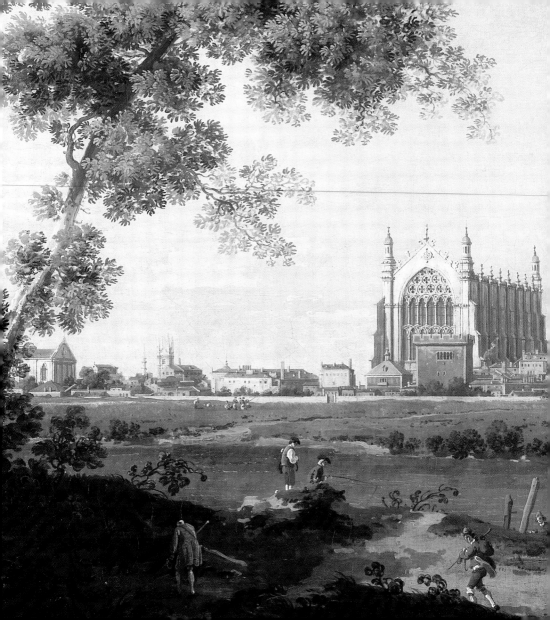

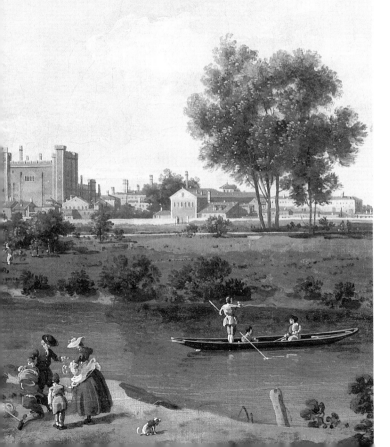

architecture in

National
Gallery

Christoffer Wilhelm Eckersberg : Detail of *View of the Forum in Rome*

First published in the United States in 1999 by
Watson-Guptill Publications, a division of BPI Communications, Inc.,
1515 Broadway, New York, NY 10036

Series Editor: Ljiljana Ortolja-Baird
Designer: Susannah Good
Design concept: Bet Ayer

Library of Congress Catalog Card Number : 99–63729

ISBN: 0 8230 0337 X

Published in the United Kingdom in 1999 by
MQ Publications Ltd., 254–258 Goswell Road,
London EC1V 7RL, in association with The National Gallery
Company Ltd., London.

Printed and bound in China

1 2 3 4 5 6 7 8 / 06 05 04 03 02 01 00 99

Title page: Canaletto, *Eton College*

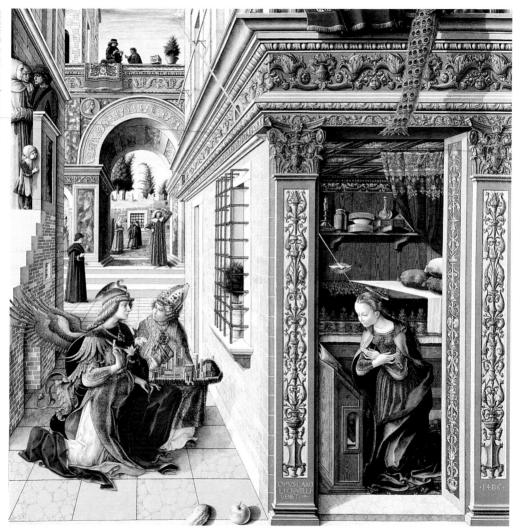

Carlo Crivelli: detail of *The Annunciation, with Saint Emidius*

INTRODUCTION

"As painting, so poetry." Like all siblings, the Sister Arts are rivals and allies. In the mirrors they hold up to nature we see ourselves and the world around us reflected from varying angles and by different lights.

The National Gallery in London houses many of the world's most famous paintings, many of which celebrate the grandeur of architecture and the ongoing dialogue between art and architecture.

Wittily juxtaposing texts and images, the book allows us to look back on these past conversations—where sometimes architecture is the subject of discussion and other times the silent backdrop.

By presenting the paintings in detail, *Architecture in Art* helps us discover aspects of these images we never "knew" were there, and by pairing text and picture, it enhances the descriptive powers of both painting and literature, encouraging us to hone our responses to each.

Erika Langmuir
Head of Education, National Gallery, 1988–1995

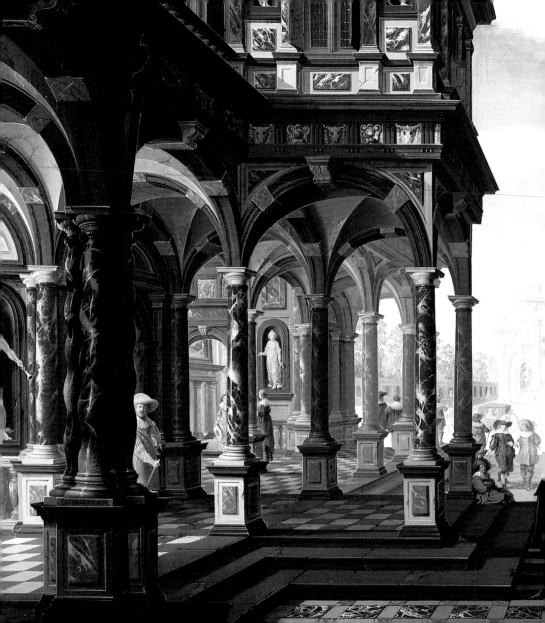

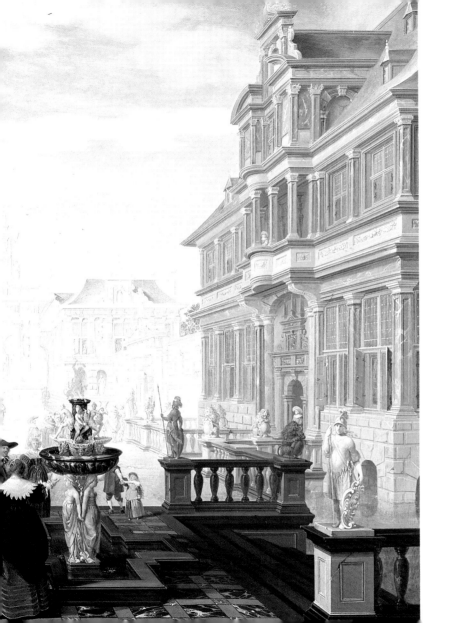

buildings

GIOVANNI PAOLO PANINI (1691–1765) Italian
Rome: The Interior of Saint Peter's
before 1742

She had not been one of the superior tourists who are 'disappointed in Saint Peter's and find it smaller than its fame'; the first time she passed beneath the huge leathern curtain that strains and bangs at the entrance, the first time she found herself beneath the far-arching dome and saw the light drizzle down through the air thickened with incense and with the reflections of marble and gilt, of mosaic and bronze, her conception of greatness rose and dizzily rose. After this it never lacked space to soar. She gazed and wondered like a child or peasant, she paid her silent tribute to the seated sublime…

The service had not yet begun, but at Saint Peter's there is much to observe, and as there is something almost profane in the vastness of the place, which seems meant as much for physical as for spiritual exercise, the different figures and groups, the mingled worshippers and spectators, may follow their various inclinations without conflict or scandal. In that splendid immensity individual indiscretion carries but a short distance.

from *Portrait of a Lady*
HENRY JAMES, 1881

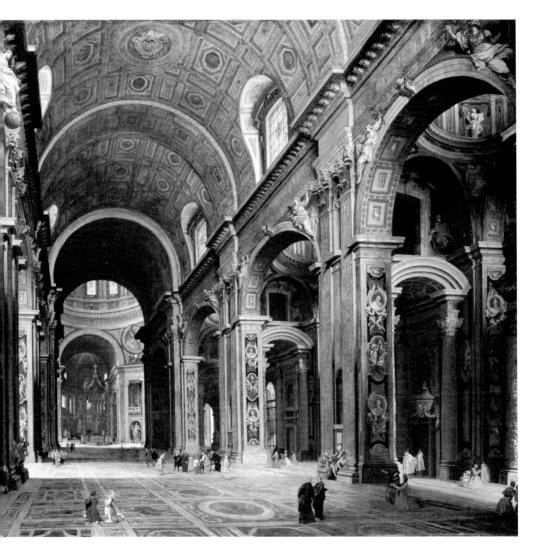

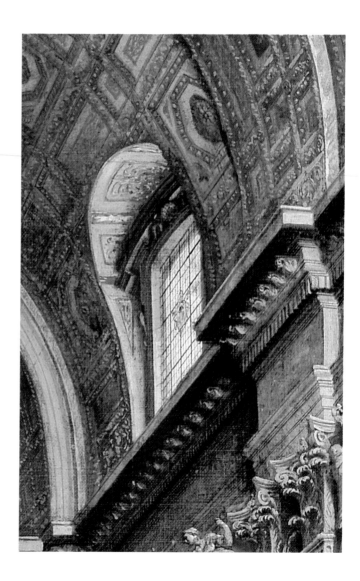

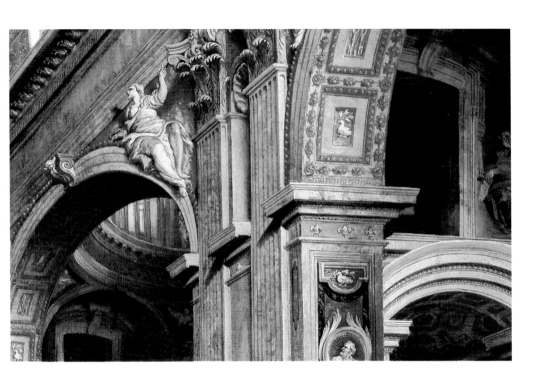

13

CAMILLE PISSARRO (1830–1903) French
The Louvre under Snow
1902

Come, see the north wind's masonry,
Out of an unseen quarry evermore
Furnished with tile, the fierce artificer
Curves his white bastions with projected roof
Round every windward stake or tree or door.
Speeding, the myriad-handed, his wild work
So fanciful, so savage, naught cares he
For number or proportion. Mockingly
On coop or kennel he hangs Parian wreaths;
A swan-like form invests the hidden thorn;
Fills up the farmer's lane from wall to wall,
Maugre the farmer's sighs; and at the gate
A tapering turret overtops the work.
And when his hours are numbered, and the world
Is all his own, retiring as he were not.
Leaves, when the sun appears, astonished Art
To mimic in slow structures, stone by stone,
Built in an age, the mad wind's night-work,
The frolic architecture of the snow.

from *The Snowstorm*
RALPH WALDO EMERSON, 1841

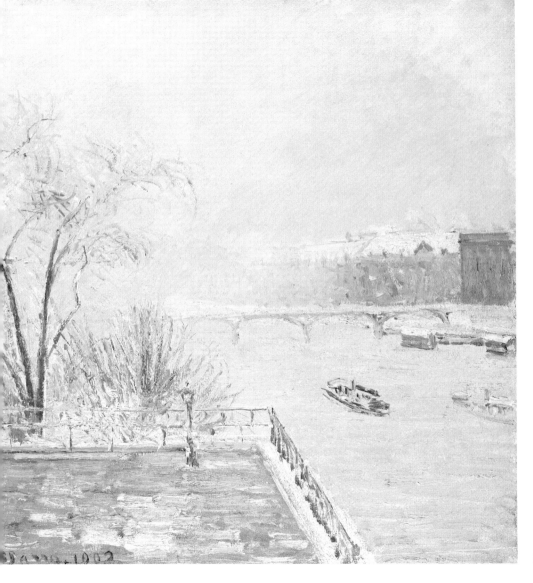

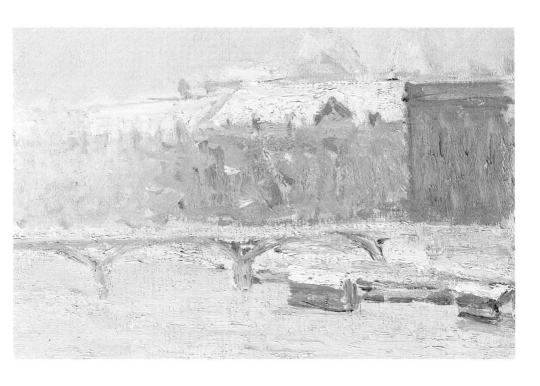

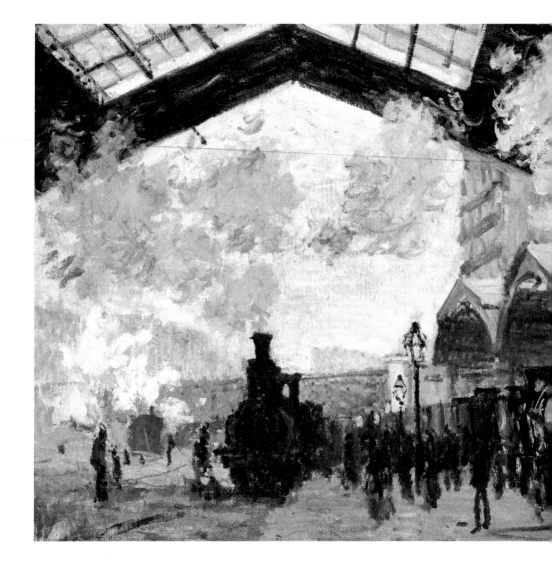

CLAUDE-OSCAR MONET (1840–1926) French
The Gare St-Lazare
1877

The fifth-floor window, at the corner of the mansard roof, looked over the station, a wide trench cutting through the Europe district like a sudden broadening out of the view, an effect made the more striking that afternoon by a grey mid-February sky, a misty, warm, greyness through which the sun was filtering.

Opposite in this vapoury sunshine, the buildings in the rue de Rome seemed hazy, as though fading into air. To the left yawned the huge roofs spanning the station with their sooty glass…To the right the Europe bridge straddled the cutting with its air of girders, and the fine lines could be seen emerging beyond and going on as far as the Batignolles tunnel… An order was shouted and the engine acknowledged with a short whistle that it had understood. Before it started there was silence, then the steam cocks were opened and the steam hissed along the ground in a deafening jet. Then he saw the white cloud billowing out from under the bridge, whirling like downy snow flying through the lattice-work…

from *La Bête humaine*
ÉMILE ZOLA, 1889

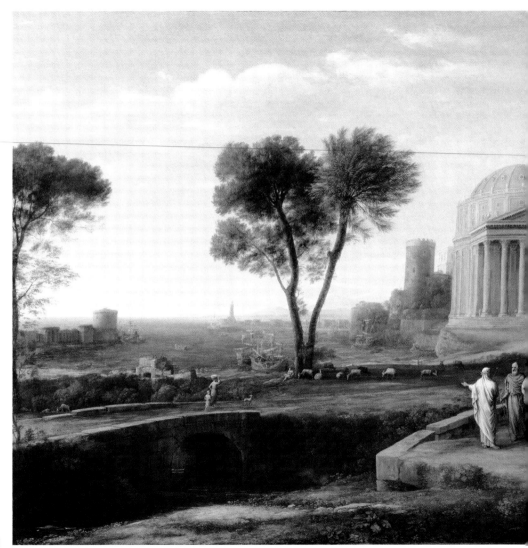

CLAUDE (1604/5?–1682) French
Landscape with Aeneas at Delos
1672

Not magnitude, not lavishness,
But form—the site;
Not innovating wilfulness,
But reverence for the archetype.

Greek Architecture
HERMAN MELVILLE, 1891

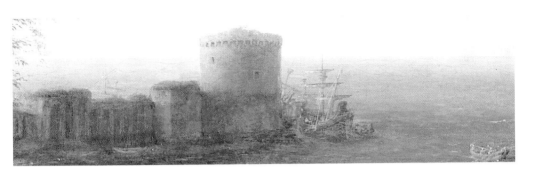

CANALETTO (1697–1768) Italian
Venice: The Doge's Palace and the Riva degli Schiavoni
late 1730s

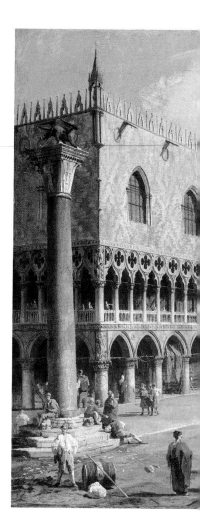

I stood in Venice on the Bridge of Sighs,
A palace and a prison on each hand:
I saw from out the wave her structures rise
As from the stroke of the enchanter's wand;
A thousand years their cloudy wings expand
Around me, and a dying glory smiles
O'er the far times, when many a subject land
Looked to the wingèd Lion's marble piles,
Where Venice sat in state, throned on her hundred isles.

She looks a sea Cybele, fresh from ocean,
Rising with her tiara of proud towers
At airy distance, with majestic motion,
And such she was; her daughters had their dowers
From spoils of nations, and the exhaustless East
Poured in her lap all gems in sparkling showers:
In purple was she robed, and of her feast
Monarchs partook, and deemed their dignity increased.

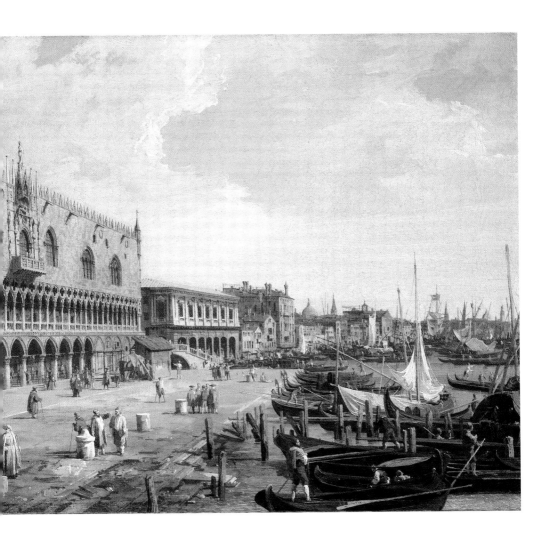

In Venice Tasso's echoes are no more,
And silent rows the songless gondolier;
Her palaces are crumbling on the shore,
And music meets not always now the ear;
Those days are gone, but Beauty is still here;
States fall, arts fade, but nature doth not die,
Nor yet forget how Venice was once dear,
The pleasant place of all festivity.
The revel of the earth, the masque of Italy.

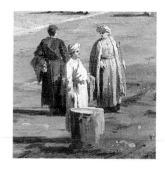

But unto us she hath a spell beyond
Her name is story, and her long array
Of mighty shadows, whose dim forms despond
Above the Dogeless city's vanished sway:
Ours is a trophy which will not decay
With the Rialto; Shylock and the Moor,
And Pierre, cannot be swept away or worn
away,—
The keystones of the arch!—though all were o'er,
For us repeopled were the solitary shore.

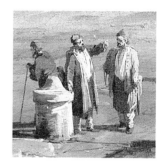

<div align="right">

from *Childe Harold's Pilgrimage*
GEORGE GORDON, LORD BYRON, 1816

</div>

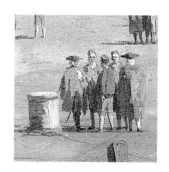

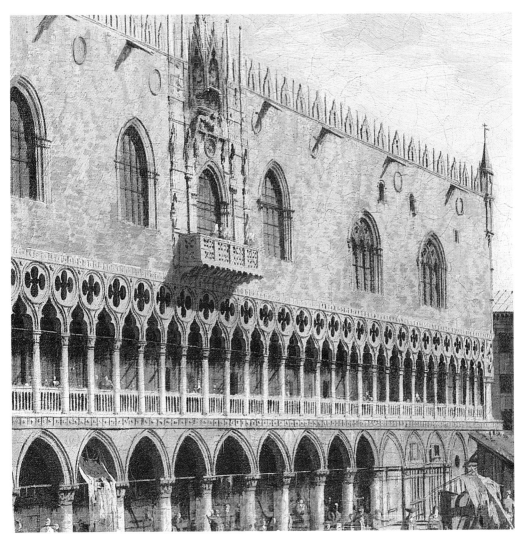

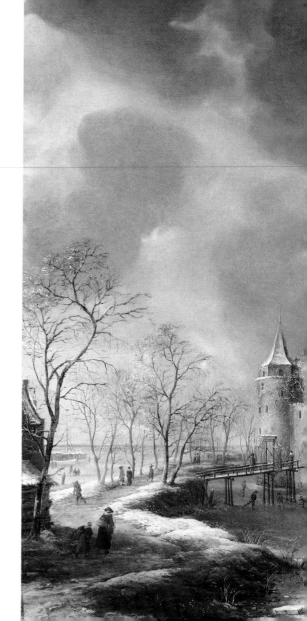

JAN BEERSTRAATEN (1622–1666)
Dutch
The Castle of Muiden in Winter
1658

The splendour falls on castle walls
 And snowy summits old in story;
The long light shakes across the lakes,
 And the wild cataract leaps in glory.
Blow, bugle, blow, set the wild echoes
 flying
Blow, bugle; answer, echoes, dying,
 dying, dying.

O, hark, O, hear! how thin and clear,
 And thinner, clearer, farther going!
O, sweet and far from cliff and scar
 The horns of Elfland faintly blowing!
Blow, let us hear the purple glens
 replying,
Blow, bugle; answer, echoes, dying,
 dying, dying.

from *Blow, Bugle, Blow*
ALFRED, LORD TENNYSON, 1850

30

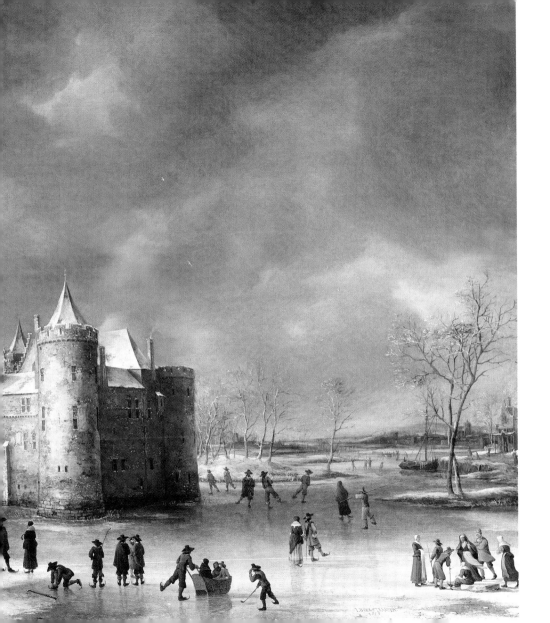

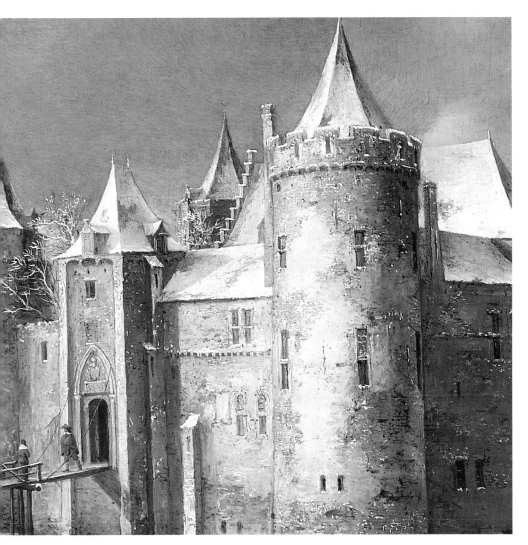

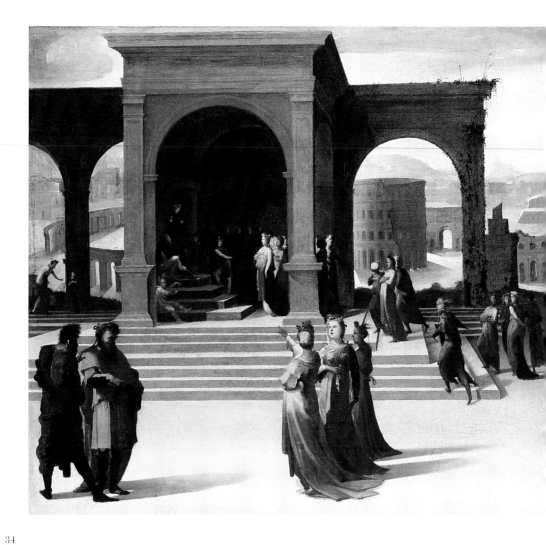

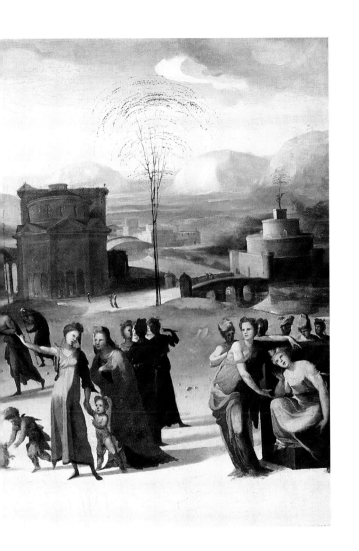

classical
ideals

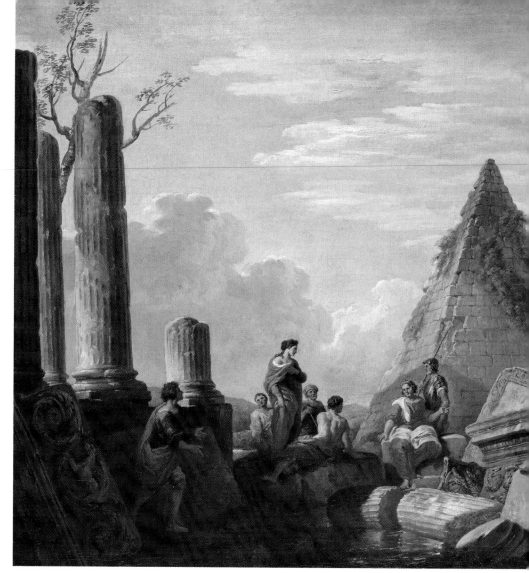

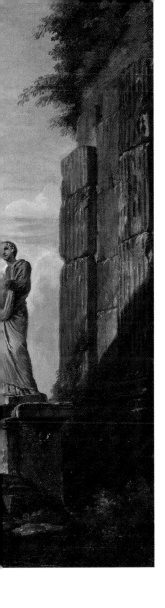

GIOVANNI PAOLO PANINI
(1691–1765) Italian
Roman Ruins with Figures
about 1730

In the field not one
fourleaf clover:
which of the three's to blame?

Empty chairs:
the statues have gone back
to the other museum.

How can you gather together
the thousand fragments
of each person?

This column has a hole:
can you see
Persephone?

In the Field not One
GEORGE SEFERIS, 1940

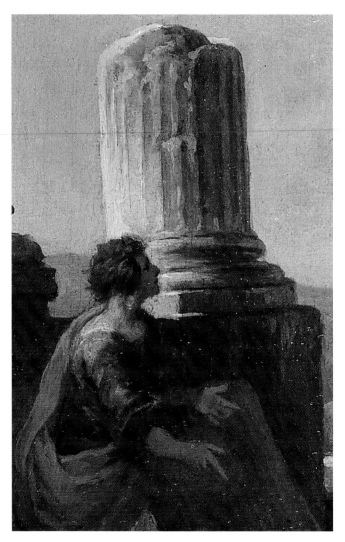

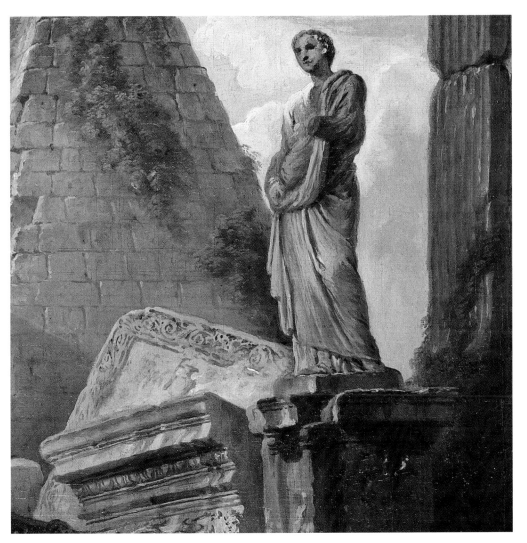

39

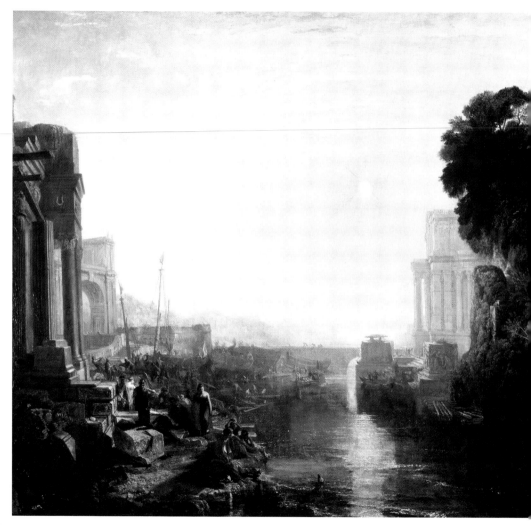

JOSEPH MALLORD WILLIAM TURNER (1775–1851)
English
Dido building Carthage, or The Rise of the Carthaginian Empire
1815

They were now climbing a massive hill which overhung the city and commanded a view of the citadel. Aeneas looked wonderingly at the solid structures springing up where there had once been only African huts, and at the gates, the turmoil and the paved streets. The Tyrians were hurrying about busily, some tracing a line for the walls and manhandling stones up the slopes as they strained to build their citadel, and others siting some building and marking its outline by ploughing a furrow. And they were making choice of laws, of officers of state, and of councillors to command their respect. At one spot they were excavating a harbour, and at another a party was laying out a foundation of a theatre; they were also hewing from quarries mighty pillars to stand tall and handsome beside the stage which was still to built…

In the heart of the city there was a group of trees giving a wealth of shade…At this spot Dido the Phoenician was building a vast and sumptuous temple for Juno; inside it the dedicated offerings were magnificent, and the goddess's powerful presence could be felt. Bronzen were the raised thresholds to which the stairways led; bronze clamped the beams; and of bronze were the doors which made the hinges groan.

from *Aeneid, Book I* 41
VIRGIL, 70–19 BC

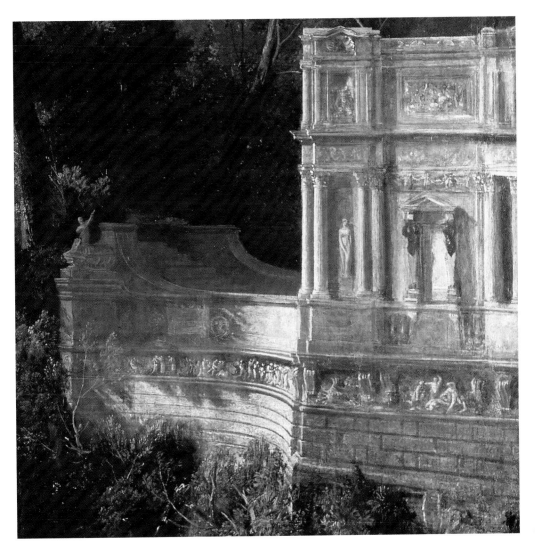

43

FRANCESCO GUARDI (1712–1793) Italian
An Architectural Caprice
1770–78

As regards the draught, this is understandable, but his dis-
like of the view needs a little explaining, since, with its trees
(rare enough in Venice to constitute a treat), its two tiny
shops...a squat wellhead at its centre, and a decaying but
elegant palazzo on the near side, the little clearing below is
one of the loveliest spots in the whole of Venice. Joseph
thinks so too, and knowing the city as well as he does he is
qualified to judge. In fact, its beauty was one of the reasons
why he chose these particular lodgings when first he came to
Venice—that and their cheapness. Yet in spite of this it is a
spot he has gradually come to dread. It is the palazzo that
bothers him, you see. Not that there is anything wrong with
the building itself, apart from the fact that it is a sad, lonely-
looking place and has acquired a local reputation for ill luck
following one or two mishaps that have taken place inside it,
but because it happens to be the home of a small arch-enemy
of Joseph's.

from *The Cabalist*
AMANDA PRANTERA, 1985

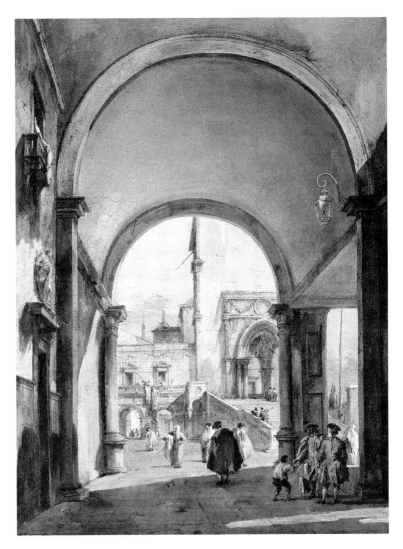

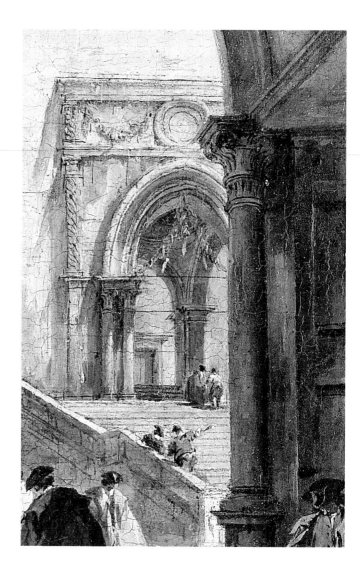

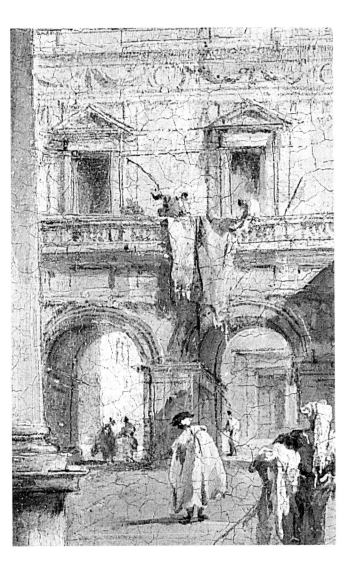

LAMBERT SUSTRIS (about 1515/20–about 1570) Dutch
Solomon and the Queen of Sheba
1550–70

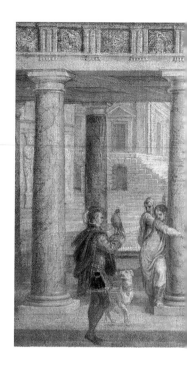

And it came to pass in the four hundred and eightieth year
after the children of Israel were come out of the land of
Egypt, in the fourth year of Solomon's reign over Israel, in
the month Zif which is the second month that he began to
build the house of the Lord.

 And the house which King Solomon built for the Lord, the
length thereof was threescore cubits, and the breadth thereof
twenty cubits, and the height thereof thirty cubits.

 And the porch before the temple of the house, twenty
cubits was the length thereof, according to the breadth of the
house; and ten cubits was the breadth thereof before the
house.

 And for the house he made windows of narrow lights.

 And against the wall of the house he built chambers round
about, against the walls of the house round about, both of
the temple and of the oracle: and he made chambers round
about.

 The nethermost chamber was five cubits broad, and the
middle was six cubits broad, and the third was seven cubits
broad; for without in the wall of the house he made narrowed
rests round about, that the beams should not be fastened in
the walls of the house.

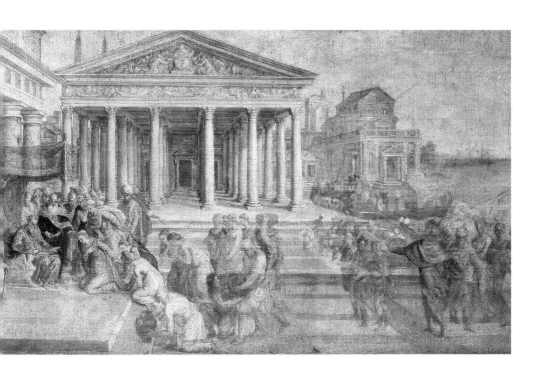

And the house when it was in building was built of stone made ready before it was brought thither: so that there was neither hammer, nor axe, nor any tool of iron heard in the house while it was in building.

And the door for the middle chamber was in the right side of the house; and they went up with winding stairs into the middle chamber, and out of the middle into the third.

So he built the house and finished it; and covered the house with beams and boards of cedar.

…and the cedar of the house within was carved with gourds and open flowers; all was cedar: there was no stone to be seen.

And the oracle he prepared in the house within, to set there the ark of the covenant of the Lord.

And the oracle in the forepart was twenty cubits in length. and twenty cubits in breadth and twenty cubits in the height thereof: and he overlaid it with pure gold; and so he covered the altar which was of cedar.

So Solomon overlaid the house within with pure gold: and he made a partition by the chains of gold before the oracle; and he overlaid it with gold.

1 KINGS 6:1–9, 18–21 (Polyglot Version)

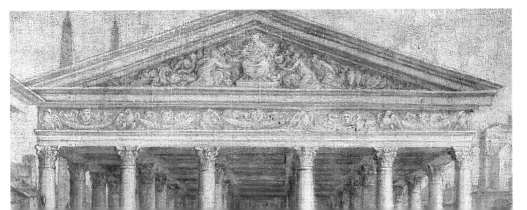

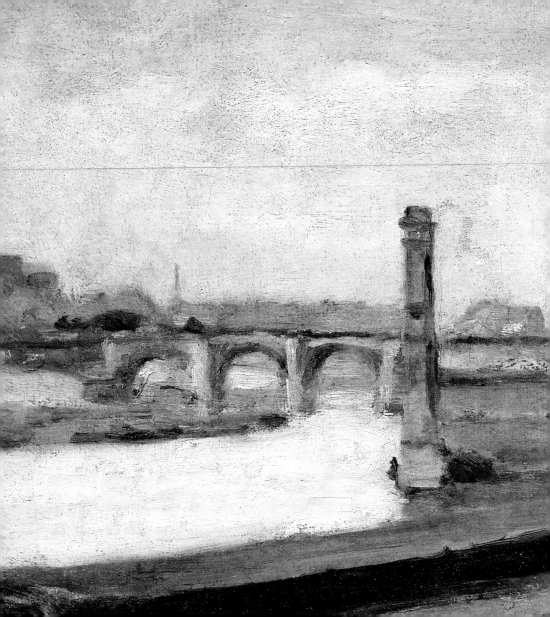

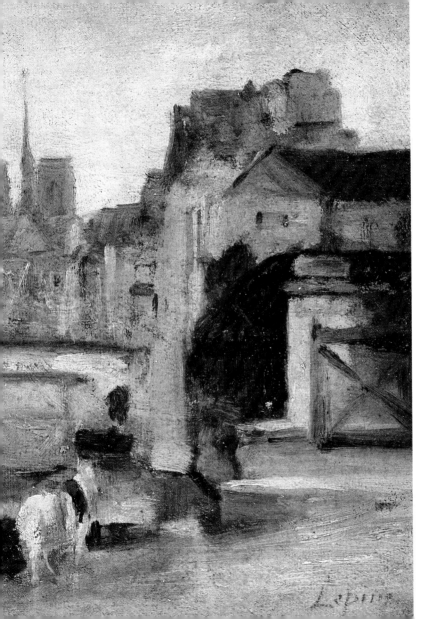

cityscapes

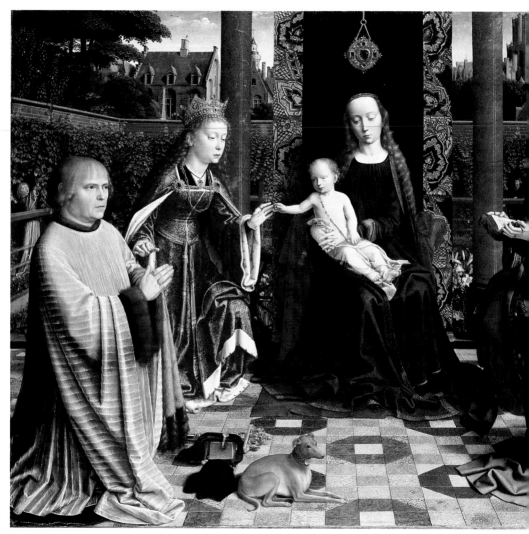

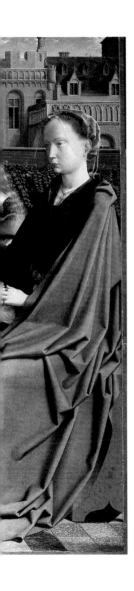

GERARD DAVID (active 1484; died 1523) Dutch
The Virgin and Child with Saints and Donor
probably 1510

I climbed the stairs in Antwerp church,
 What time the circling thews of sound
 At sunset seem to heave it round,
Far up the carillon did search
The wind, and the birds came to perch
 Far under where the gables wound.

In Antwerp harbour on the Scheldt
 I stood alone, certain space
 Of night. The mist was near my face;
Deep on, the flow was heard and felt.
The carillon kept pause, and dwelt
 In music through the silent place.

John Memmeling and John van Eyck
 Hold state at Bruges. In sore shame
 I scanned the works that keep their name.
The carillon, which then did strike
Mine ears, was heard of theirs alike:
 It set me closer unto them.

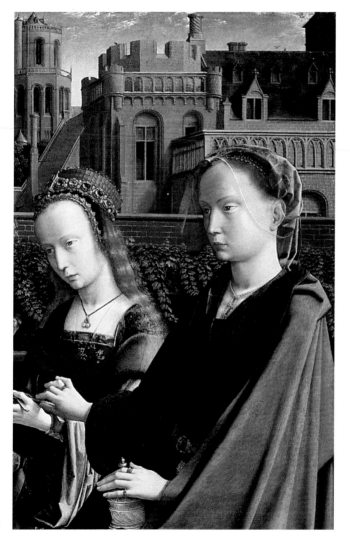

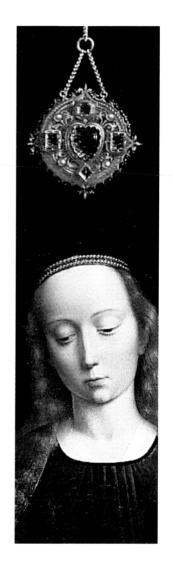

56

I climbed at Bruges all the flight
 The belfry has of ancient stone.
 For leagues I saw the east wind blown;
The earth was grey, the sky was white.
I stood so near upon the height
 That my flesh felt the carillon.

Antwerp and Bruges
DANTE GABRIEL ROSSETTI, nineteenth century

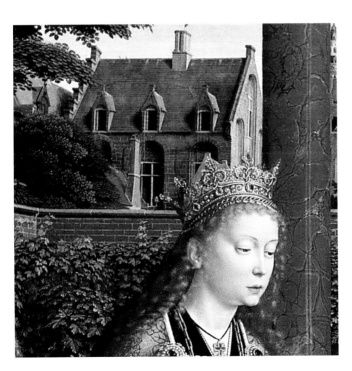

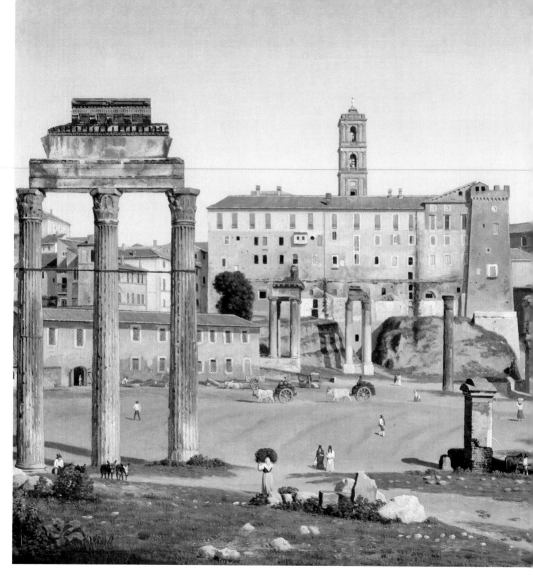

CHRISTOFFER WILHELM ECKERSBERG (1783–1853)
Danish
View of the Forum in Rome
1814

They love old Rome, antique Rome, they love the fora with
their battered grandeur, they love looking at the ancient hills
in the evenings, the views of cypresses and solitary pines,
they love the functionless pillars, the marble staircases lead-
ing nowhere, the sundered arches over the filled-in chasms
commemorating victories whose names figure in school-
books, they love the House of Augustus and they quote from
Horace and Vergil, they adore the Rotunda of the Vestal
Virgins, and they pray at the Temple of Fortune. I listen to
them, speaking knowledgeably of new finds, discussing
archaeological digs and museum treasures; and I love them
too, love the old gods, love beauty long buried in the ground
now visible once more, I love the proportions and the smooth
cold stone skin of the old statuary, but still more I love Rome
as it is now, alive and manifest to me, I love its skies,
Jupiter's fathomless sea...

from *Death in Rome*
WOLFGANG KOEPPEN, pub. 1992
trans: Michael Hofmann

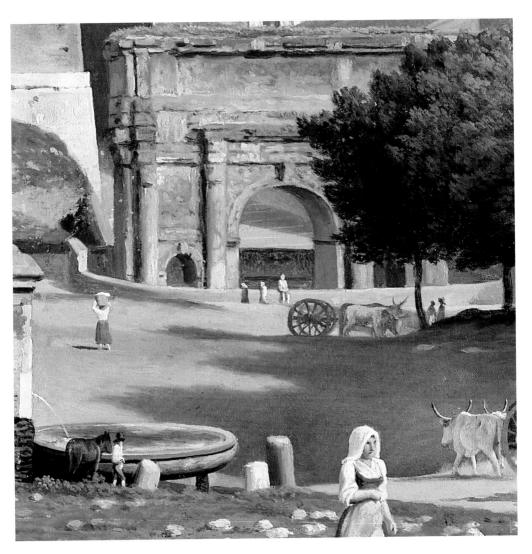

61

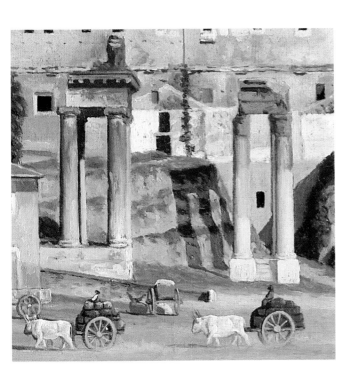

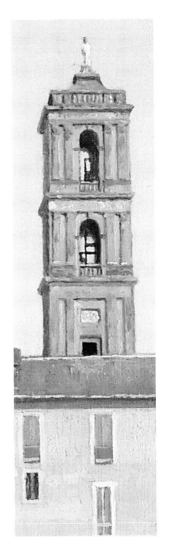

CLAUDE-OSCAR MONET (1840–1926) French
The Thames below Westminster
about 1871

Here any classical form or idea is against the grain. Such a bog as this is, for the antique arts, a place of exile. When the Romans landed here they must have though themselves in Homer's inferno, in the land of the Cimerians. The vast space which, in the south lies between earth and heaven, is missed here, by the seeking eye; no more air, nothing but the flowing of fog. In this livid smoke, objects are no more than phantoms and nature looks like a bad drawing in charcoal on which someone has rubbed his sleeve.

I have just spent half an hour on Waterloo Bridge. 'Parliament House', indistinct, outline washed out seems, in the distance, no more than a wretched huddle of scaffolding; nothing perceptible, above all nothing alive, except the small steamboats moving on the river, black, smoky, indefatigable insects: a Greek, seeing their passengers embark and disembark, would have thought of the Styx. He would have considered that to live here was not to live at all; and, indeed, here men live otherwise than in Greece—the ideal has changed with the climate…Here, it is necessary to have a well kept 'home', clubs, associations, much business, a quantity of religious and moral preoccupations.

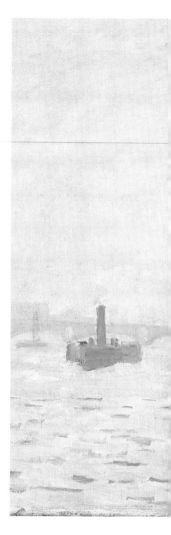

from *Notes on England*
HIPPOLYTE TAINE, 1871

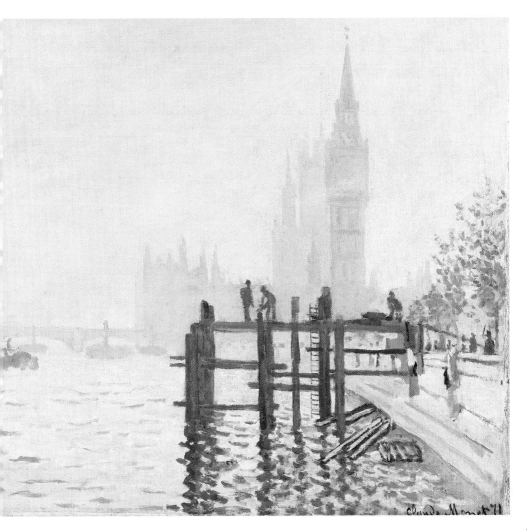

Claude Monet 71

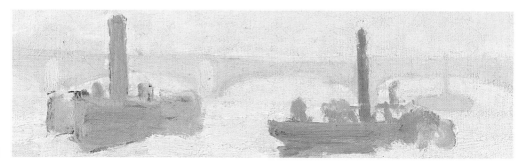

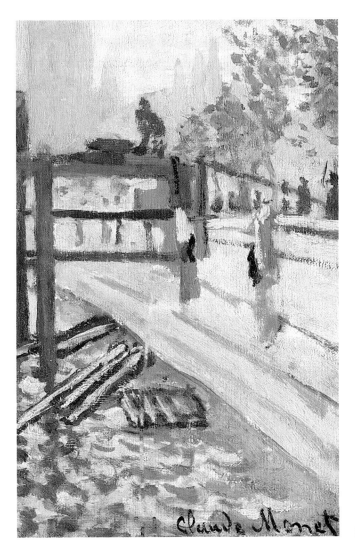

ANDREA MANTEGNA (about 1430/1–1506) Italian
The Agony in the Garden
about 1460

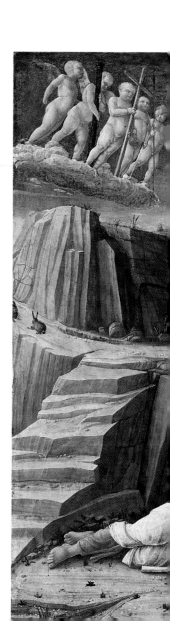

His heart, to me, was a place of palaces and pinnacles and
 shining towers;
I saw it then as we see things in dreams—I do not remember
 how long I slept;
I remember the trees, and the high, white walls, and how the
 sun was always on the towers—
The walls are standing to-day, and the gates: I have been
 through the gates, I have groped, I have crept
Back, back. There is dust in the streets, and blood; they are
 empty; darkness is over them;
His heart is a place with the lights gone out, forsaken by
 great winds and the heavenly rain, unclean and unswept,
Like the heart of the holy city, old, blind, beautiful
 Jerusalem,
Over which Christ wept.

<div align="right">

I Have Been Through the Gates
CHARLOTTE MEW, early twentieth century

</div>

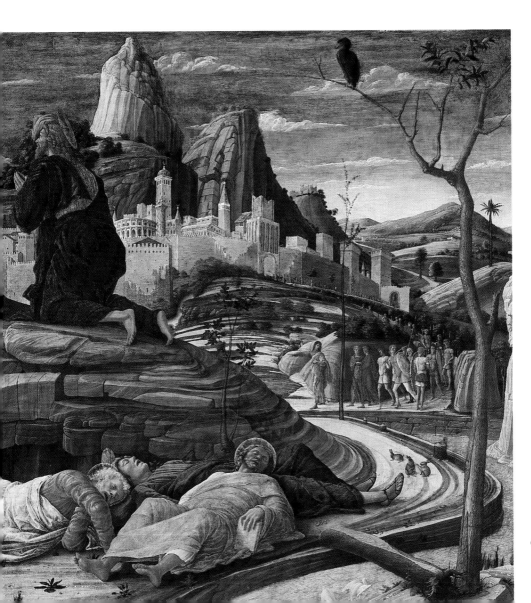

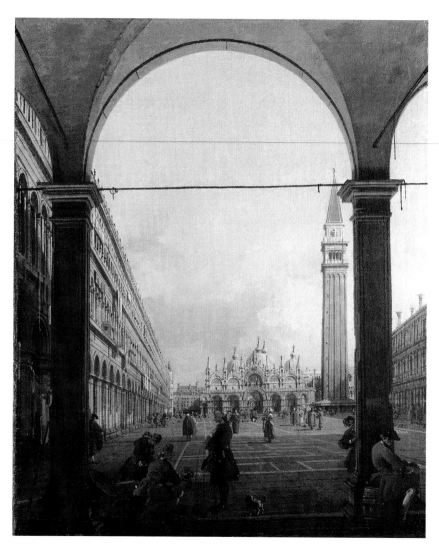

Canaletto (1697–1768) Italian
Venice: Piazza San Marco
about 1756

…between those pillars there opens a great light, and, in the midst of it, as we
advance slowly, the vast tower of Saint Mark seems to lift itself visibly forth from
the level field of chequered stones; and, on each side, the countless arches prolong
themselves into ranged symmetry, as if the rugged and irregular houses that
pressed themselves together above us in the dark alley had been struck back into
sudden obedience and lovely order, and all their rude casements and broken walls
had been transformed into arches charged with goodly sculpture and fluted shafts
of delicate stone…beyond those troops of ordered arches there rises a vision out of
the earth, and all the great square seems to have opened from it in a kind of awe,
that we may see it far away; a multitude of pillars and white domes, clustered into a
long low pyramid of coloured light; a treasure heap, it seems partly of gold, and
partly of opal and mother of pearl, hollowed beneath into five great vaulted porches,
ceiled with fair mosaic and beset with sculpture of alabaster, clear as amber and
delicate as ivory,—sculpture fantastic and involved, of palm leaves and lilies and
grapes and pomegranates, and birds clinging and fluttering among the branches,
all twined together into an endless network of buds and plumes; and, in the midst of
it, the solemn forms of angels, sceptered and robed to the feet, and leaning to each
other across the gates, their figures indistinct among the gleaming of the
golden ground through the leaves beside them, interrupted and dim, like the
morning light as it faded back among the branches of Eden, when first its gates
were angel-guarded long ago.

<div align="right">

from *The Stones of Venice, vol. II, chap. iv*
John Ruskin, 1851–1853

</div>

74

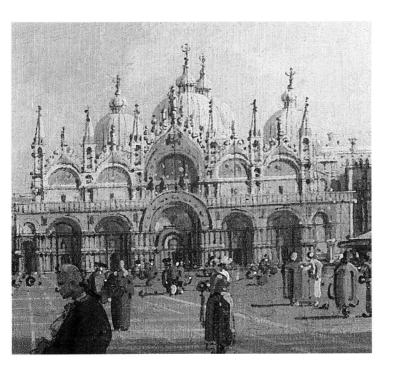

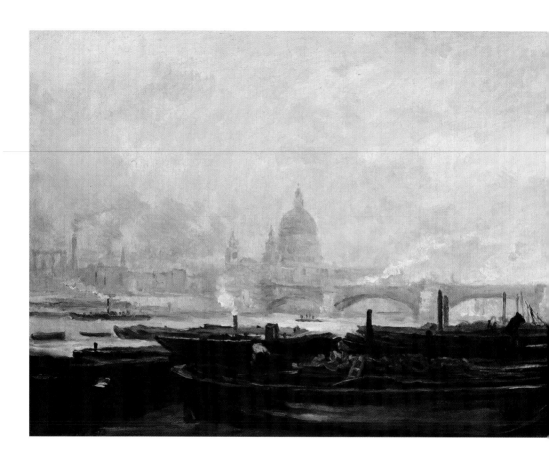

CHARLES-FRANÇOIS DAUBIGNY (1817–1878) French
St Paul's from the Surrey Side
1873

An omnibus across the bridge
 Crawls like a yellow butterfly,
And, here and there, a passer-by
Shows like a little restless midge.

Big barges full of yellow hay
 Are moored against the shadowy wharf,
 And, like a yellow silken scarf,
The thick fog hangs along the quay.

The yellow leaves begin to fade
 And flutter from the Temple elms,
 And at my feet the pale green Thames
Lies like a rod of rippled jade.

Symphony in Yellow
OSCAR WILDE, 1889

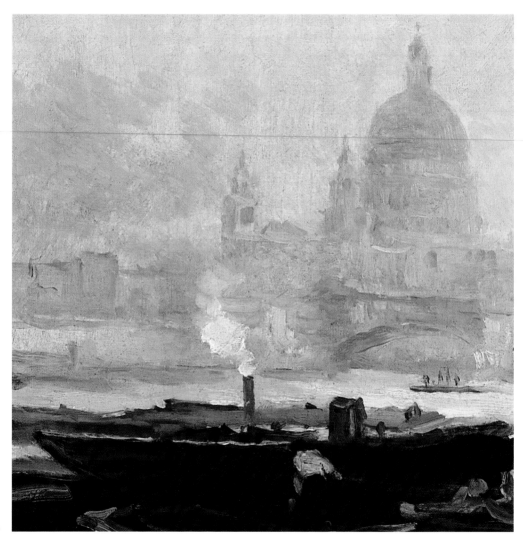

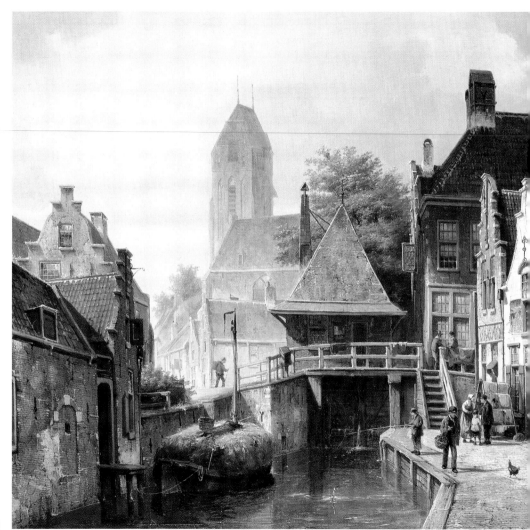

WILLEM KOEKKOEK (1839–1895) Dutch
View of Oudewater
about 1867

Far, far back during the Second World War, a certain Anton
Steenwijk lived with his parents and his brother on the out-
skirts of Haarlem. There four houses stood close together
along a quay that bordered the water for about a hundred
metres. After a gentle curve, the quay straightened out and
became an ordinary street. Each house was surrounded by a
garden and had a little balcony, bay windows, and a steep
roof, giving it the air of a modest villa. The rooms on the top
floor all had slanted walls. The houses were somewhat dilapi-
dated and in need of paint, for their upkeep had already
been neglected during the thirties. Harking back to lighter-
hearted days, each bore an honest sign with its name:
Hideaway, Carefree, Home at Last, Bide-a-Wee.

from *The Assault*
HARRY MULISCH, pub. 1982
trans: Claire Nicolas

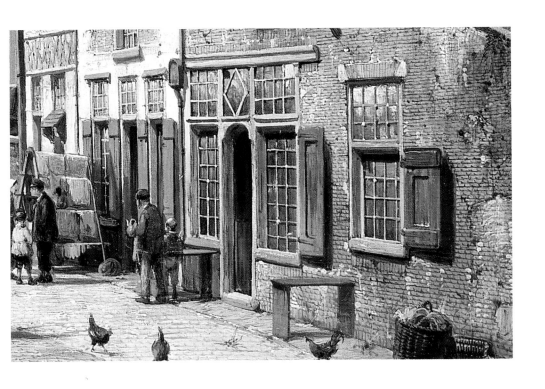

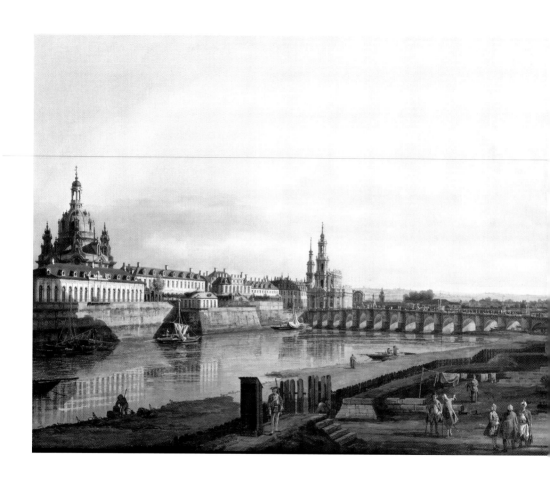

BERNARDO BELLOTTO (1720–1780) Italian
View of Dresden from the Right Bank of the Elbe
about 1752

Earth has not anything to show more fair:
Dull would he be of soul who could pass by
A sight so touching in its majesty:
This city now doth, like a garment, wear
The beauty of the morning;
Silent, bare ships, towers, domes, theatres, and temples lie
Open unto the fields, and to the sky;
All bright and glittering in the smokeless air.
Never did sun more beautifully steep
In his first bright splendour, valley, rock, or hill
Ne'er saw I, never felt, a calm so deep!
The river glideth at his own sweet will:
Dear God! the very houses seem asleep;
And all that mighty heart is lying still!

Composed upon Westminster Bridge, Sept. 3, 1802
WILLIAM WORDSWORTH

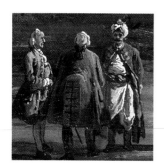

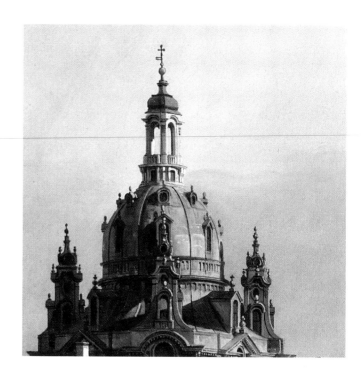

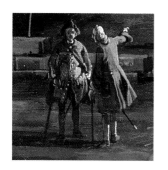

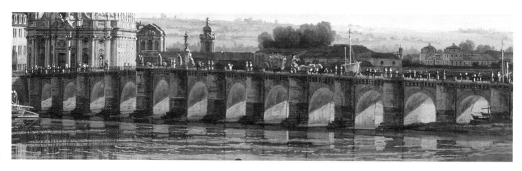

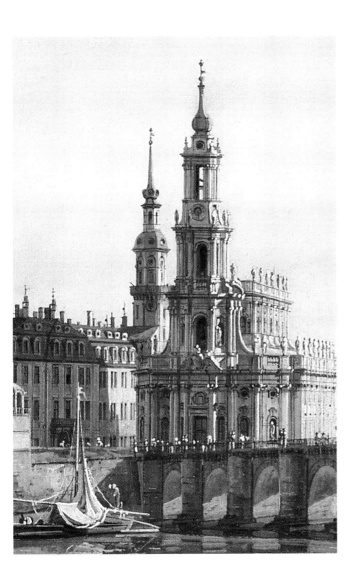

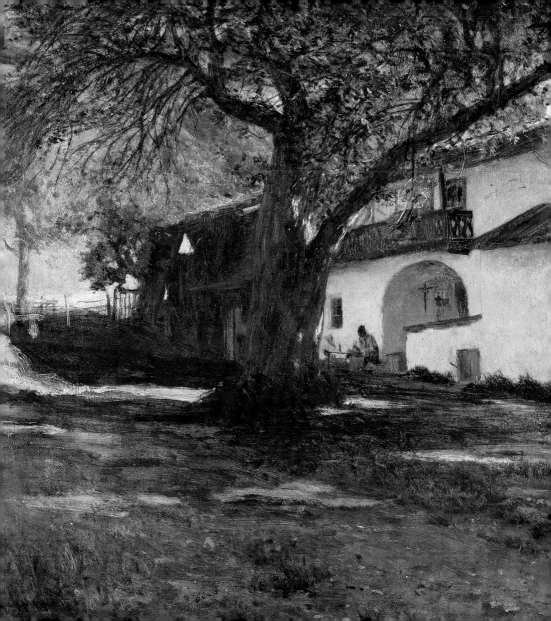

rustic
dreams

FRANÇOIS BOUCHER (1703–1770) French
Landscape with a Watermill
1755

I see a mill glistening
Through some alders,
Above rustling and singing
I hear a mill-wheel churn.

Through the trees
On the breeze,
Today will be heard just one rhyme,
The mill-girl, whom I love, is mine!

Enjoy the peace and quiet.
Shut your eyes.
You are now home, exhausted wanderer.
Here is loyalty,
Lie with me
Until the ocean drinks all rivers.

<div align="right">

from *The Beautiful Mill-girl*
WILHELM MÜLLER, 1821
trans. Jack Hibberd

</div>

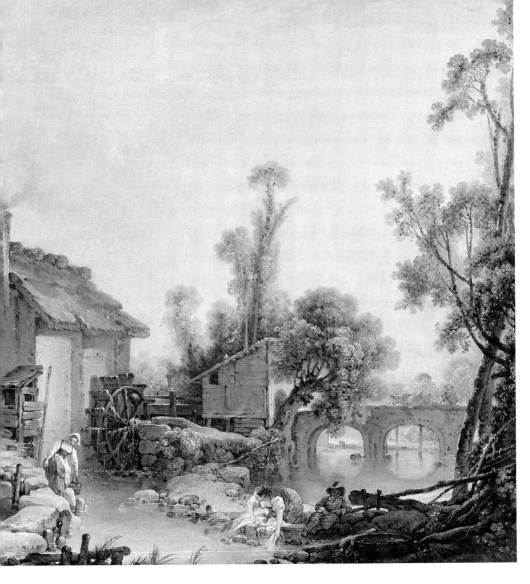

JAN BRUEGHEL the ELDER
(1568–1625) Flemish
The Adoration of the Kings
1598

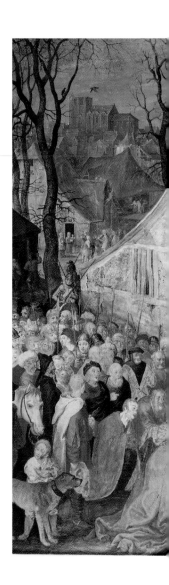

Behould a sely tender Babe
 In freesing winter nighte,
In homely manger trembling lies;
 Alas, a pitious sighte!

The inns are full, no man will yelde
 This little pilgrime bedd;
But forc'd He is with sely beastes
 In cribbe to shroude His headd.

Despise Him not for lyinge there,
 First what He is enquire;
An orient perle is often founde
 In depth of dirty mire.

Waye not His cribb, His wodden dishe,
 Nor beastes that by Him feede;
Waye not His mother's poor attire,
 Nor Josephe's simple weede.

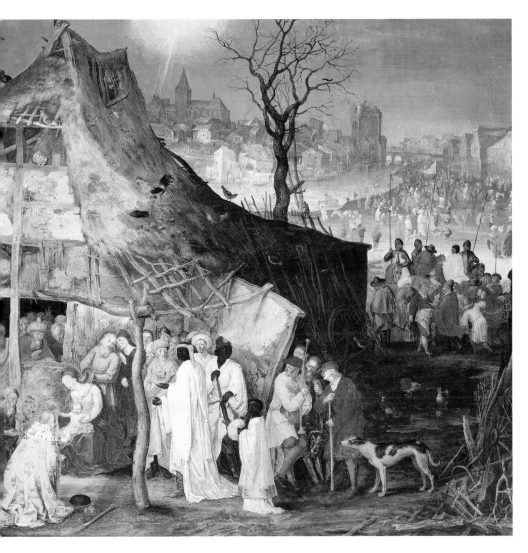

This stable is a Prince's courte,
 The cribbe His chaire of State;
The beastes are parcell of His pompe,
 The woodden dishe His plate.

The parsons in that poore attire
 His royall liveries weare;
The Prince Himself is come from heaven,
 This pompe is prisèd there.

from *New Prince, New Pompe*
ROBERT SOUTHWELL, 1600s

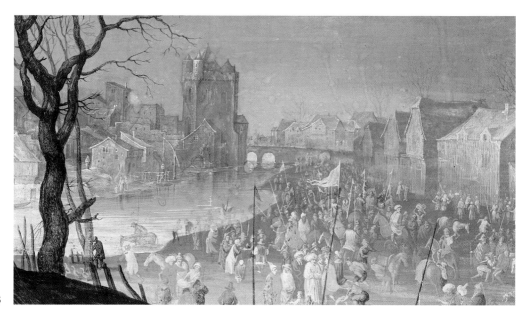

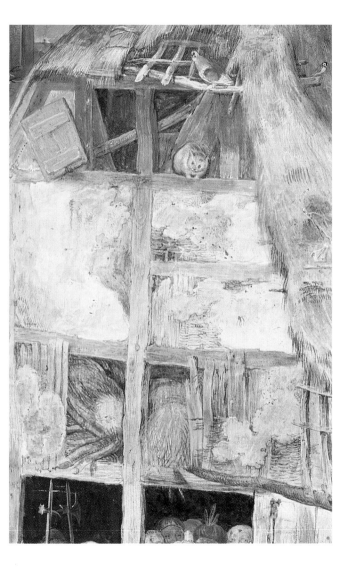

97

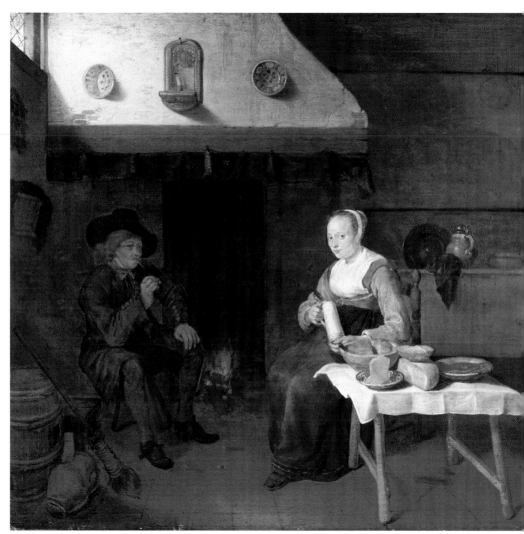

QUIRINGH VAN BREKELENKAM
(1644–1668) Dutch
*An Interior, with a Man and a Woman
seated by a Fire*
1653

Sweet hours have perished here;
 This is a mighty room;
Within its precincts hopes have played,
 Now shadows in a tomb.

<div align="right">

Sweet Hours have Perished Here
EMILY DICKINSON, pub. 1924

</div>

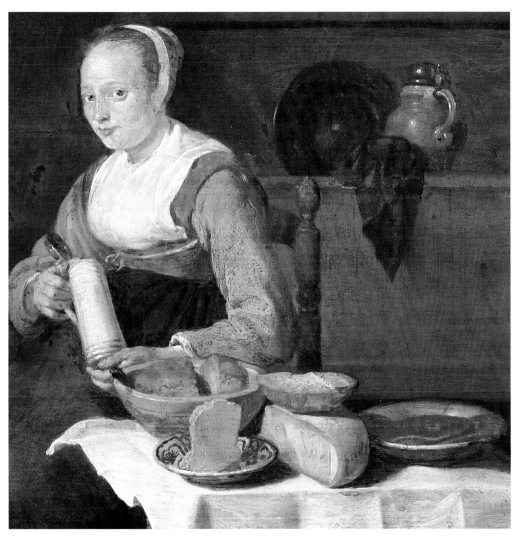

ISACK VAN OSTADE (1621–1649) Dutch
A Farmyard
about 1640

Good God and can it be that such a nook
As this can raise such sudden rapture up
—Two dotterel trees an oak and ash that stoop
Their aged bodys oer a little brook
and raising their sheltering head above and oer
A little hovel raised on four old props
Old as themselves to look on and what more
Nought but an 'awthorn hedge and yet one stops
In admiration and joy to gaze
Upon these objects feeling as I stand
That nough in all this wide worlds thorny ways
Can match this bit of feelings fairy land
How can it be—time owns the potent spell
I've known it from a boy and love it well.

The Milking Shed
JOHN CLARE, C. 1830

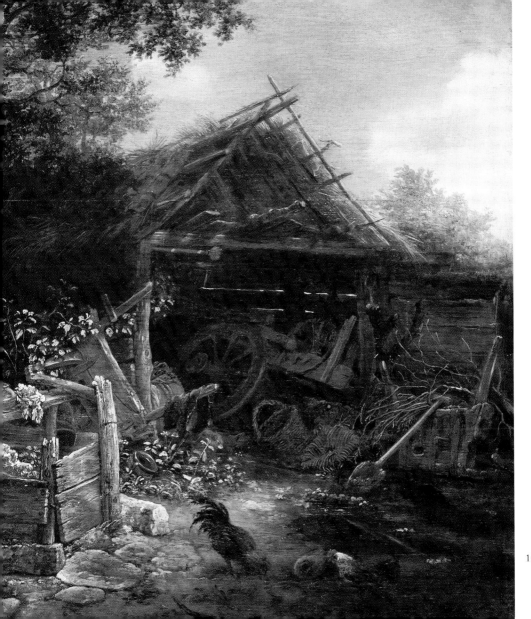

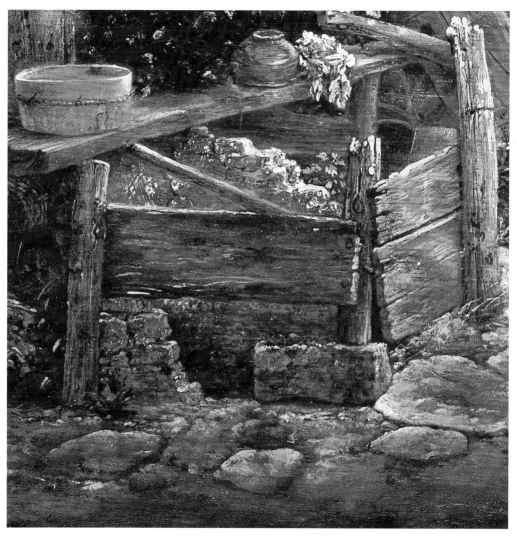

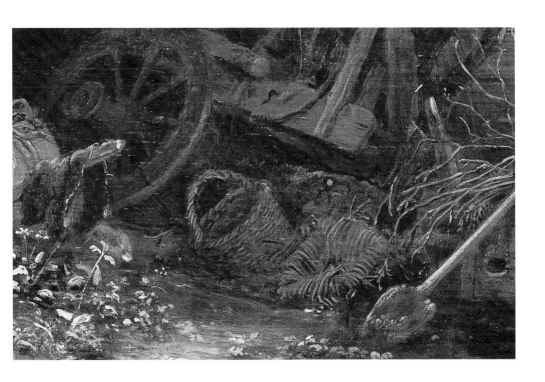

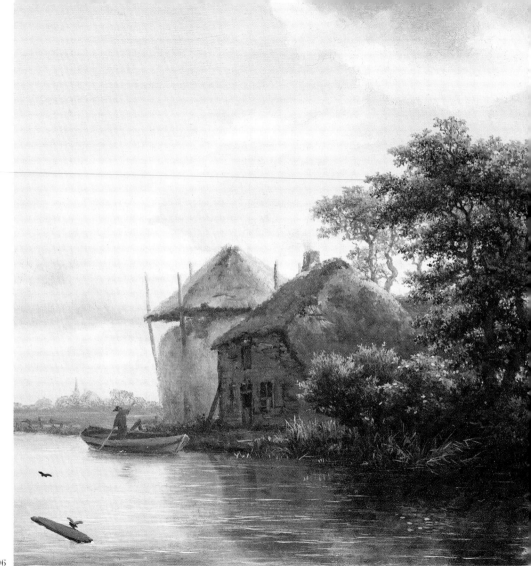

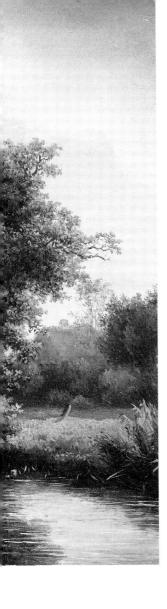

JACOB VAN RUISDAEL (1628/9?–1682) Dutch
A Cottage and a Hayrick by a River
about 1646–50

These plots of cottage-ground, these orchard tufts,
Which at this season, with their unripe fruits,
Are clad in one green hue, and lose themselves
'Mid groves and copses. Once again I see
These hedgerows, hardly hedgerows, little lines
Of sportive wood run wild; these pastoral farms,
Green to the very door: and wreaths of smoke
Sent up, in silence from among the trees!
With some uncertain notice as might seem
Of vagrant dwellers in the houseless woods,
Or of some Hermit's cave, where by his fire
The hermit sits alone.

from *Tintern Abbey*
WILLIAM WORDSWORTH, 1798

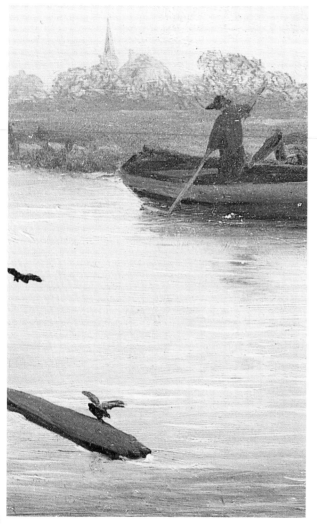

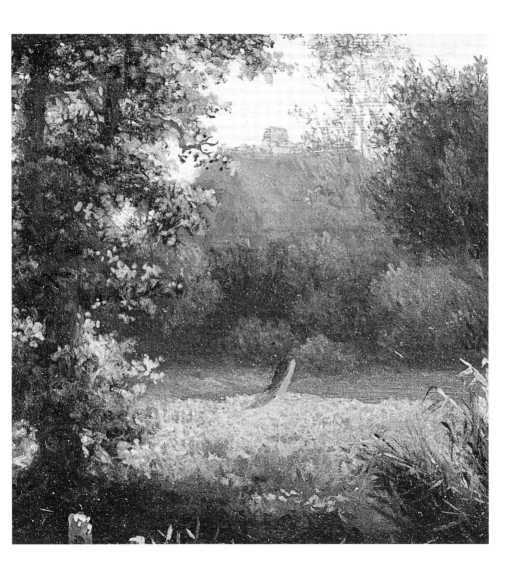

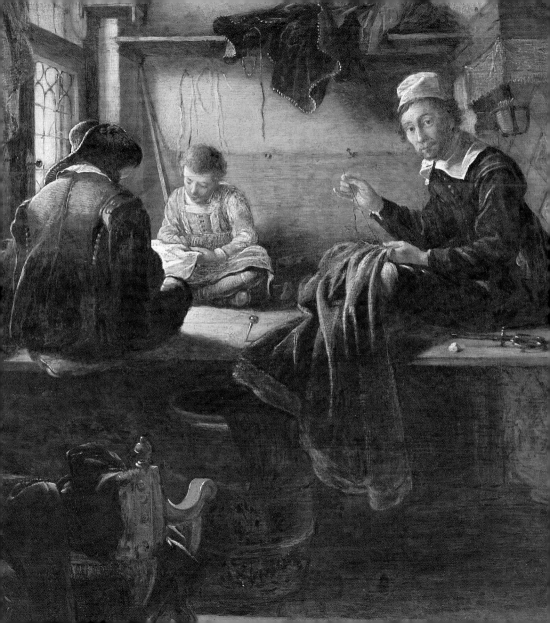

interiors

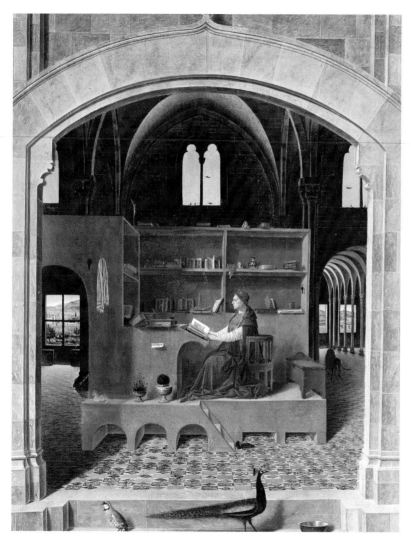

Antonello da Messina (active 1456; died 1479) Italian
Saint Jerome in his Study
about 1475

I am an injured man.

I depart and return, Pietà, to where I talk and listen, to myself, alone.

I have only arrogance and goodness.

I feel in exile among humankind.

For whom I am tortured.

If only I could turn to myself again.

I have populated silence with words.

Have I splintered heart and mind with a tyranny of words?

I rule over revenants.

<div align="right">

from *La Pietà*
Giuseppe Ungaretti, 1958
trans. Jack Hibberd

</div>

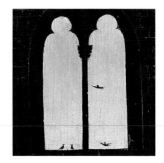

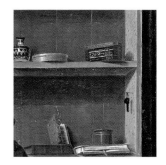

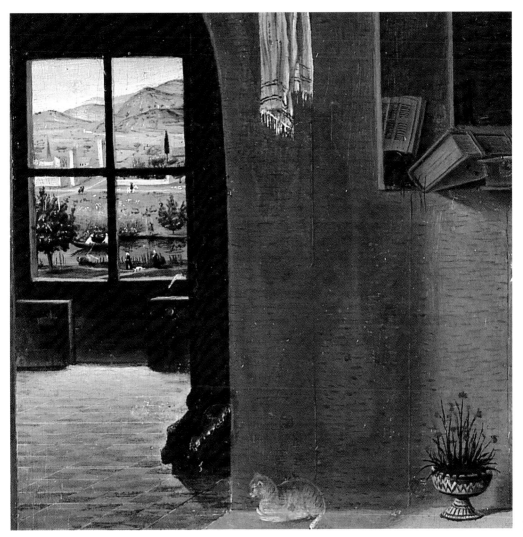

WILLIAM HOGARTH (1697–1764) English
Marriage à la Mode: II, Shortly after the Marriage
before 1743

First of all you must do away with all recesses in the reception room. A cupboard, even if it only has room for half a dozen pots of jam, should be enclosed with walls. Remember that you are making preparations for war, and that the first thought of a general is to cut off his enemy's supplies. The walls should be plain, affording lines such as the eye can easily take in at a glance and such as will immediately expose any strange element that may have crept in.

You must above all bring all your energies into play when applying this magnificent system of defence to the arrangement of your wife's room...ruthlessly cut her off by moving her to one end of the reception rooms.

You will no doubt have learnt from *The Marriage of Figaro* that you had better give your wife a room at a great height from the ground—all bachelors are Cherubins.

<div style="text-align:right">

from *The Physiology of Marriage*
HONORÉ DE BALZAC, nineteenth century

</div>

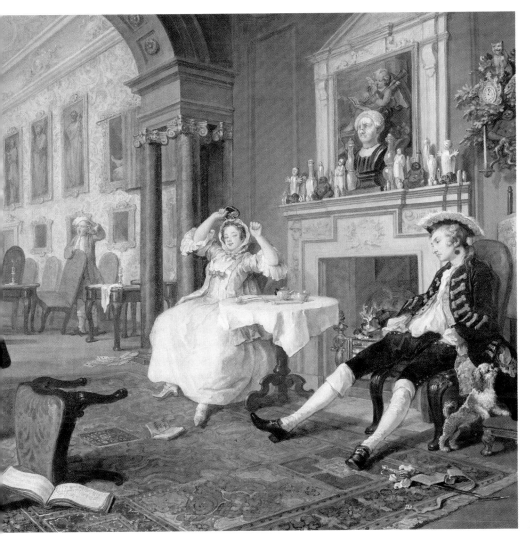

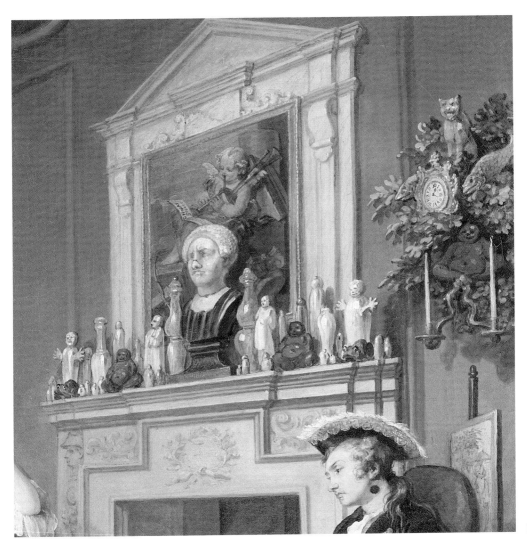

FLEMISH

Cognoscenti in a Room hung with Pictures
about 1620

Show me a gallery of air
And walls shored up with paintings through
Which we can climb. A step, a stair
Take us to sunsets or a view
Of light sufficient to a square
Of harlequinning people who

Set minds to music. Do you hear
A murmur of continued flight?
Paint, sound and word are everywhere,
A quick kaleidoscope of light.
Are paintings far or are we near
This texture of, this sound of sight?

In a Picture Gallery
ELIZABETH JENNINGS, 1975

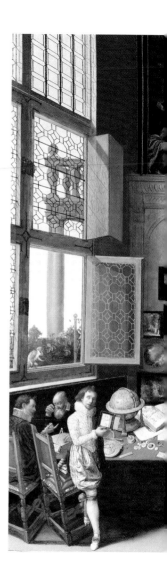

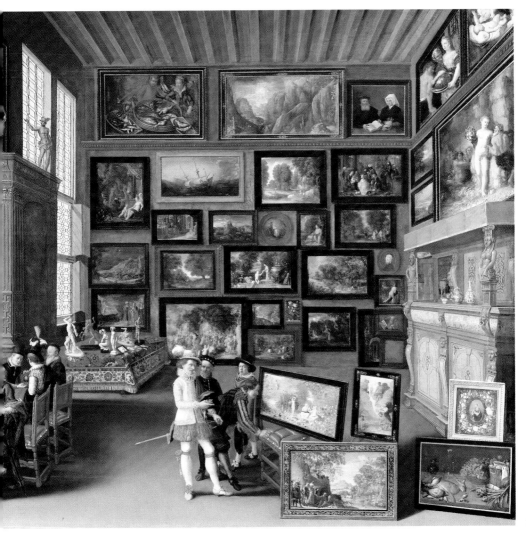

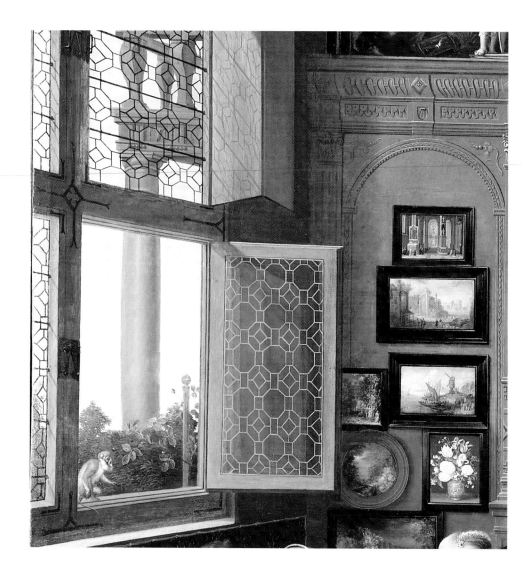

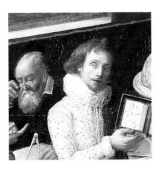

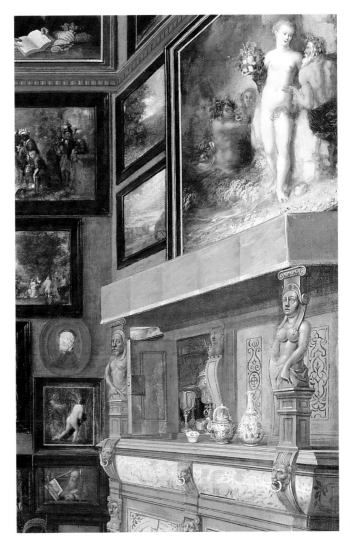

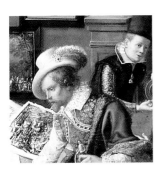

123

JAN VERMEER (1632–1675) Dutch
A Young Woman standing at a Virginal
about 1670

This hand was entirely weightless, and kissing it was almost
like kissing the ivory crucifix that was held out to me before
I went to sleep. At this low desk, with its drop-leaf open in
front of her, she would sit as if at a harpsichord. "There is
so much sunlight in it," she said, and indeed the interior was
remarkably bright…These colours, and the green of the nar-
row horizontal border of arabesques, were as dim as the
background was luminous (though it wasn't really distinct).
This resulted in a strangely muted harmony of tones, which
stood in intimate relation to one another, without stating it
explicitly.

from *The Notebooks of Malte Laurids Brigge*
RAINER MARIA RILKE, 1910

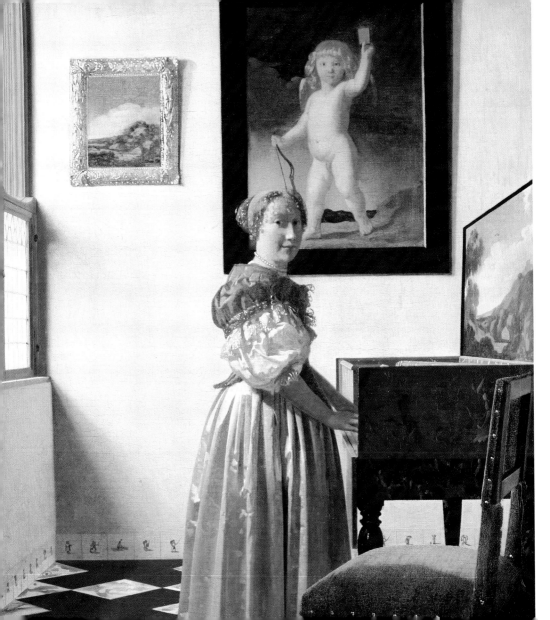

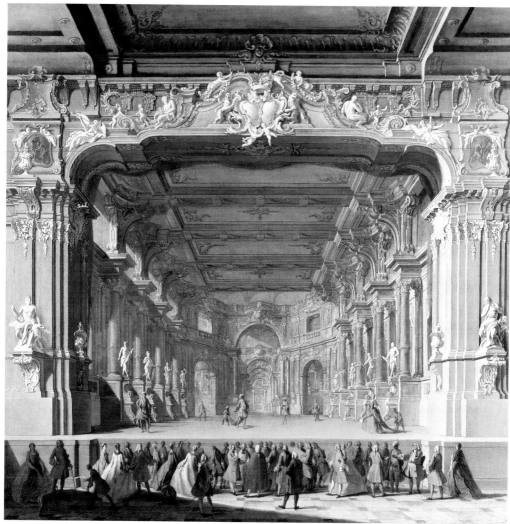

ITALIAN, NORTH
The Interior of a Theatre
probably 1700–50

It is surrounded by infinite multitudes of cherubs, angels, and saints, each gazing in rapture into the light, while whole legions of demons or fallen angels are driven out of the heavenly regions, with gestures of despair. The crowded scene seems to burst the frame of the ceiling, which brims over with clouds carrying saints and sinners right down into the church. In letting the picture thus break the frame, the artist wants to confuse and overwhelm us, so that we no longer know what is real and what illusion. A painting like this has no meaning outside the place for which it was made. Perhaps it is no coincidence, that, after the development of the full Baroque style, in which all artists collaborated in the achievement of one effect, painting and sculpture as independent arts declined in Italy and throughout Catholic Europe.

In the eighteenth century Italian artists were mainly superb internal decorators, famous throughout Europe for their skill in stucco work and for their great frescoes, which could transform any hall of a castle or monastery into a setting for pageantry.

<div align="right">from The Story of Art

E. H. GOMBRICH, 1950</div>

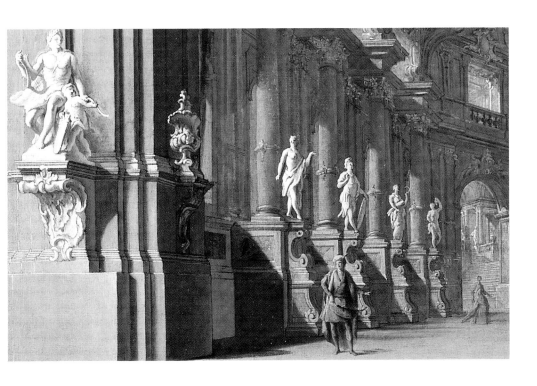

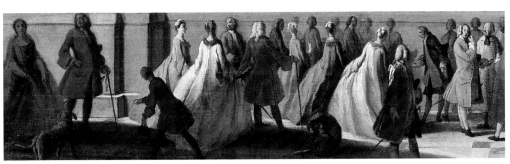

SAMUEL VAN HOOGSTRATEN (1627–1678) Dutch
A Peepshow with Views of the Interior of a Dutch House
about 1655–60

The rooms and days we wandered through
Shrink in my mind to one—there you
Lie quite absorbed by peace—the calm
Which life could not provide is balm
In death. Unseen by me, you look
Past bed and stairs and half-read book
Eternally upon your home,
The end of pain, the left alone.
I have no friend, or intercessor,
No psychopomp or true confessor
But only you who know my heart
In every cramped and devious part—
Then take my hand and lead me out,
The sky is overcast with doubt,
The time has come, I listen for
Your words of comfort at the door,
0 guide me through the shoals of fear—
"Furchte dich nicht, ich bin bei dir."

from *An Exequy*
PETER PORTER, 1978

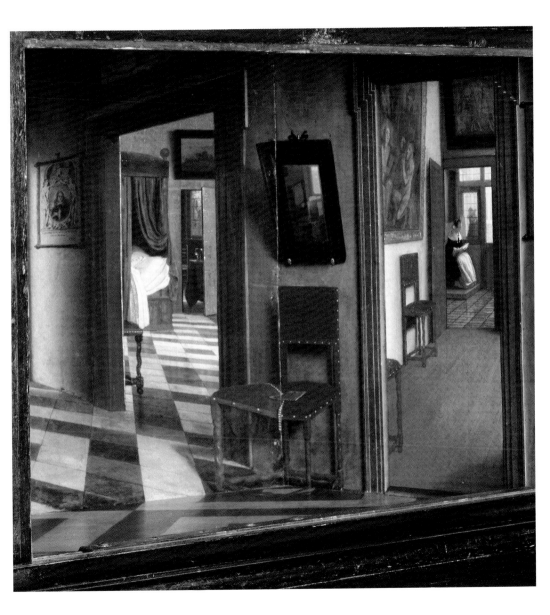

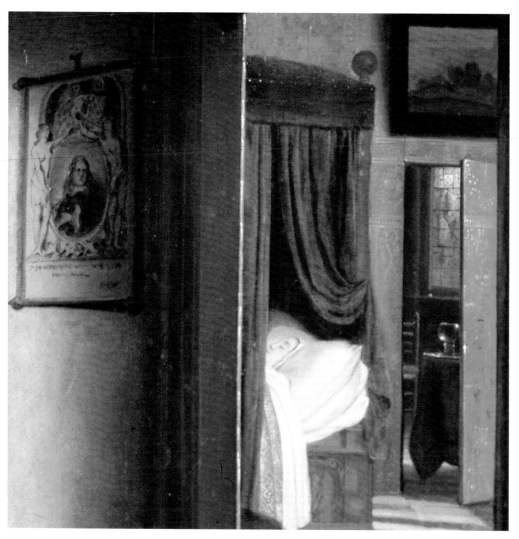

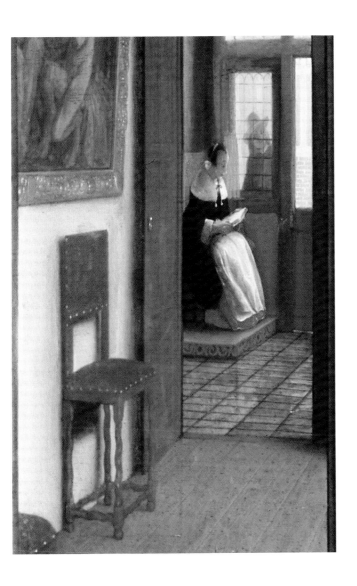

BARTHOLOMEUS VAN BASSEN (active 1613; died 1652)
Dutch? or Flemish?)
Interior of St Cunerakerk, Rhenen
1638

Wealth gotten by vanity
shall be diminished: but he
that gathereth by labour shall
increase.

The rich man's wealth is
his strong city, and as an high
wall in his own conceit.

Wealth maketh many friends;
but the poor is separated from
his neighbour.

As a dog returneth to his
vomit, so a fool returneth to
his folly.

A word fitly spoken is
like apples of gold in pictures
silver.

from PROVERBS (King James Version)

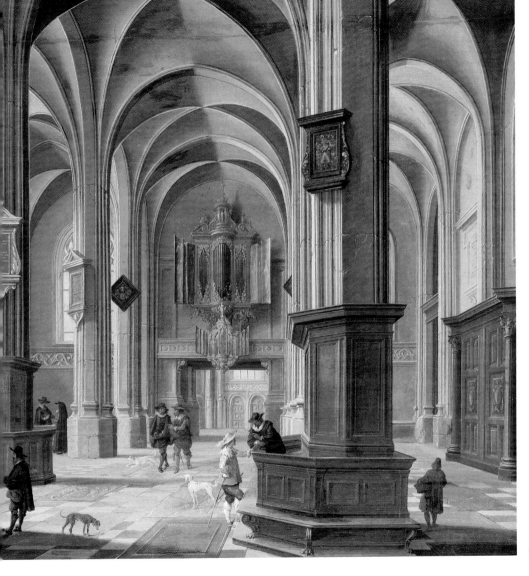

ARTISTS & PAINTINGS

FLEMISH
Cognoscenti in a Room hung with Pictures
oil on oak
95.9 x 123.5 cm, p.120

GUARDI, Francesco
An Architectural Caprice
oil on canvas
54.2 x 36.2 cm, p.45

HOGARTH, William
Marriage à la Mode: II, Shortly after the Marriage
oil on canvas
69.9 x 90.8 cm, p.116

HOOGSTRATEN, Samuel van
A Peepshow with Views of the Interior of a Dutch House
oil and egg (identified) on wood, exterior measurements
58 x 88 x 60.5 cm, p.133

ITALIAN, North
The Interior of a Theatre
oil on canvas
104.8 x 112.4 cm, p.128

KOEKKOEK, Willem
View of Oudewater
oil on canvas
64.8 x 84.4 cm, p.80

LÉPINE, Stanislas-Victor-Edmond
The Pont de la Tournelle, Paris
oil on canvas
13.7 x 24.4 cm, p.52

MANTEGNA, Andrea
The Agony in the Garden
tempera on wood
62.9 x 80 cm, p.68

MONET, Claude-Oscar
The Gare St-Lazare
oil (identified) on canvas
54.3 x 73.6 cm, p.18

The Thames below Westminster
oil on canvas
47 x 72.5 cm, p.64

OSTADE, Isack van
A Farmyard
oil on oak
40 x 41 cm, p.102

PANINI, Giovanni Paolo
Roman Ruins with Figures
oil on canvas
49.5 x 63.5 cm, p.36

Rome: The Interior of Saint Peter's
oil on canvas
149.8 x 222.7 cm, p.10

PISSARRO, Camille
The Louvre under Snow
oil on canvas
65.4 x 87.3 cm, p.14

RUISDAEL, Jacob van
A Cottage and a Hayrick by a River
oil on oak
26 x 33.4 cm, p.106

SUSTRIS, Lambert
Solomon and the Queen of Sheba
oil on canvas
78.8 x 185.4 cm, p.48

TURNER, Joseph Mallord William
Dido building Carthage, or The Rise of the Carthaginian Empire
oil on canvas
155.6 x 231.8 cm, p.40

VERMEER, Jan
A Young Woman standing at a Virginal
oil on canvas
51.7 x 45.2 cm, p.125

Writers & Works

BALZAC, Honoré de
(1799–1850) French
The Physiology of Marriage,
early 19th century, p.116

BIBLE
1 Kings 6:1–9, 18–21, p.48

Proverbs, p.136

BYRON, George Gordon
(1788–1824) English
Childe Harold's Pilgrimage,
1816, p.26

CLARE, John
(1793–1864) English
The Milking Shed, c.1830,
p.102

DICKINSON, Emily
(1830–1886) American
*Sweet Hours have Perished
Here,* pub. 1924, p.99

EMERSON, Ralph Waldo
(1803–1882) American
The Snowstorm, 1841, p.14

GOMBRICH, E. H.
(1909–) English
The Story of Art, 1950, p.129

JAMES, Henry
(1843–1916) American
Portrait of a Lady, 1881,
p.10

JENNINGS, Elizabeth
(1926–) English
In a Picture Gallery, 1975,
p.120

KOEPPEN, Wolfgang
(1906–1996) German
Death in Rome, pub. 1992,
p.59

MELVILLE, Herman
(1819–1891) American
Greek Architecture, 1891,
p.23

MEW, Charlotte
(1869–1928) English
*I have been Through the
Gates,* early 20th century,
p.68

MULISCH, Harry,
(1927–) Dutch
The Assault, pub. 1982, p.81

MÜLLER, Wilhelm
(1794–1827) German
The Beautiful Mill-girl, 1821,
p.90

PORTER, Peter
(1929–) Australian
An Exequy, 1978, p.132

PRANTERA, Amanda
(1942–) English
The Cabalist, 1985, p.44

RILKE, Rainer Maria
(1875–1926) Austrian
*The Notebooks of Malte
Laurids Brigge,* 1910, p.124

ROSSETTI, Dante Gabriel
(1828–1882) English
Antwerp and Bruges,
19th century, p.55

RUSKIN, John
(1819–1900) English
The Stones of Venice,
1851–1853, p.73

SEFERIS, George
(1900–1971) Greek
In the Field not One, 1940,
p.37

SOUTHWELL, Robert
(c. 1561–1595) English
New Prince, New Pompe,
17th century, p.94

Acknowledgments

Taine, Hippolyte
(1828–1893) French
Notes on England, 1871, p.64

Tennyson, Alfred
(1809–1892) English
Blow, Bugle, Blow, 1850,
p.30

Ungaretti, Giuseppe
(1888–1970) Italian
La Pietà, 1958, p.113

Virgil
(70–19 BC) Roman
Aeneid, 31–19 BC, p.41

Wilde, Oscar
(1854–1900) Irish
Symphony in Yellow, 1889,
p.77

Wordsworth, William
(1770–1850) English
*Composed upon Westminster
Bridge, September 3, 1802*,
p.85

Tintern Abbey, 1798, p.107

Zola, Émile
(1840–1902) French
La Bête humaine, 1890, p.19

The editor and publishers gratefully acknowledge permission to reprint copyright material below. Every effort has been made to contact the original copyright holders of the material included. Any omissions will be rectified in future editions.

The Cabalist by Amanda Prantera published by Bloomsbury, © Amanda Prantera.

In a Picture Gallery by Elizabeth Jennings from *Collected Poems* published by Carcanet.

The Story of Art by E. H. Gombrich © 1995 Phaidon Press Limited. Text © 1995 E.H. Gombrich.

An Exequy by Peter Porter © Peter Porter 1983. Reprinted from *Collected Poems* by Peter Porter (1983) by permission of Oxford University Press.

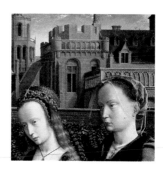

Gérard David: detail of *The Virgin and Child with Saints and Donor*

Title page: Canaletto: *Eton College*, about 1754
Buildings title page: Dirck van Delen: *An Architectural Fantasy*, 1876
Classical Ideals title page: Domenico Beccafumi: *An Unidentified Scene*, probably 1540–50
Cityscapes title page: Stanislas-Victor-Edmond Lépine: *The Pont de la Tournelle, Paris*, 1862–64
Rustic Dreams title page: Dutch (?): *A White House among Trees*, 19th century
Interiors title page: Quiringh van Brekelenkam: *Interior of a Tailor's Shop*, about 1655–61